Drawing Anime School Girl Stills Activity Book

Bobo's Children Activity Books

All Rights reserved. No part of this book may be reproduced or used in any way or form or by any means whether electronic or mechanical, this means that you cannot record or photocopy any material ideas or tips that are provided in this book.

Copyright 2016

INSTRUCTIONS FOR DRAWING:

THIS HOW-TO DRAWING BOOK CONSISTS OF IMAGES THAT ARE PLACED ON GRIDS. THERE IS A DRAWING BOX LOCATED AT THE LOWER PART OF THE PAGE AND THAT WILL SERVE AS YOUR PRACTICE SPACE. TO COPY THE IMAGE, DRAW PARTS OF THE IMAGE PER GRID AND PUT THEM ON THE BIGGER GRIDS. SOUNDS DIFFICULT? NOT REALLY. TRY IT FIRST!

IT'S OKAY IF YOU DON'T COPY THE IMAGE PERFECTLY. AFTER ALL, DRAWING IS ABOUT THE EXPRESSION OF YOUR PERCEPTION AS WELL AS YOUR HAND STRENGTH AND CONTROL.

WHEN YOU'VE COPIED THE IMAGE, GO AND AHEAD AND COLOR IT NEXT! WE'RE EXCITED TO SEE WHAT YOU CAN DO!

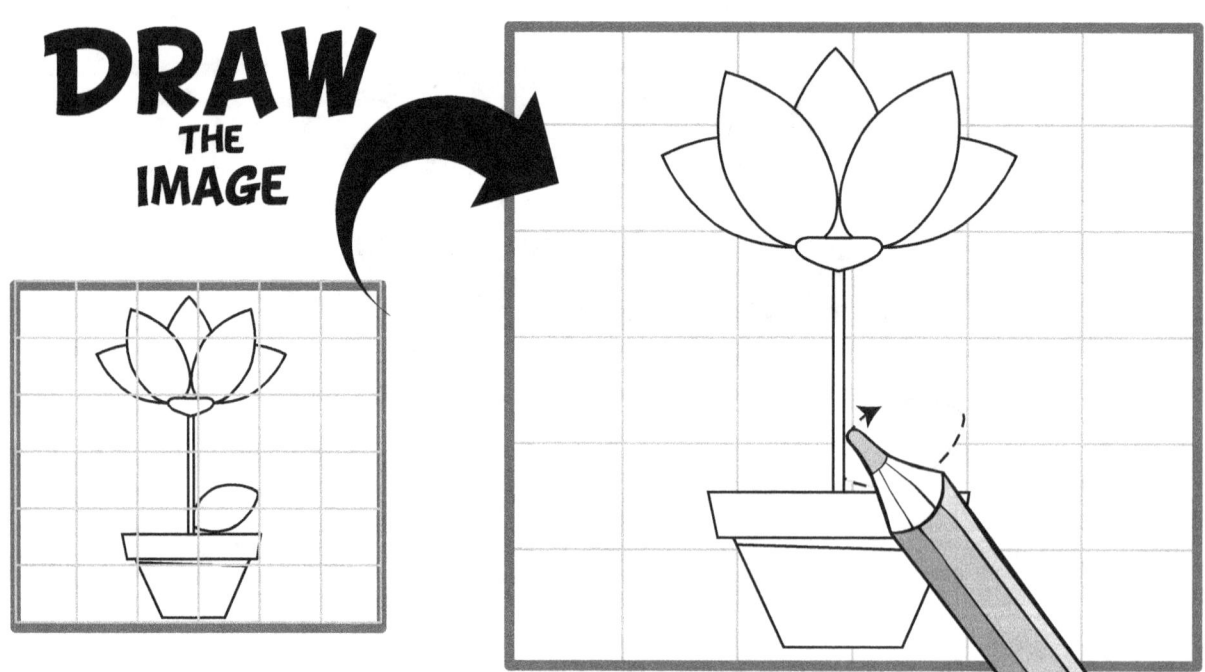

This is a Bleed Through Page If You Are Using a Coloring Marker or Pen!
Find Other Great Titles By searching for BoBo's Children Activity Books *on Your Favorite Book Retailer*
Amazon.Com | Barnes & Noble (BN.Com) | Books A Million (BAM.Com)

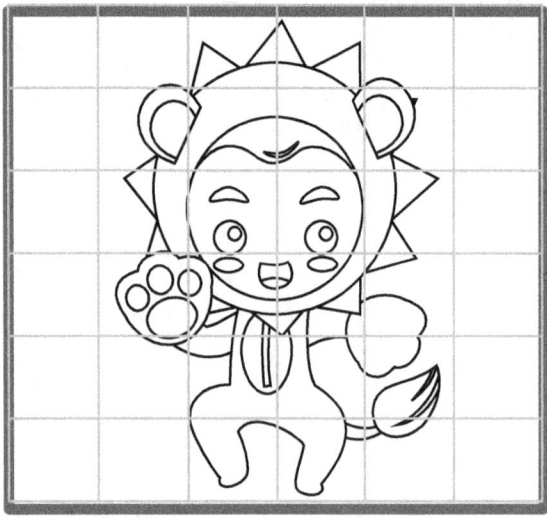

DRAW
THE
IMAGE

This is a Bleed Through Page If You Are Using a Coloring Marker or Pen!
Find Other Great Titles By searching for BoBo's Children Activity Books on Your Favorite Book Retailer
Amazon.Com | Barnes & Noble (BN.Com) | Books A Million (BAM.Com)

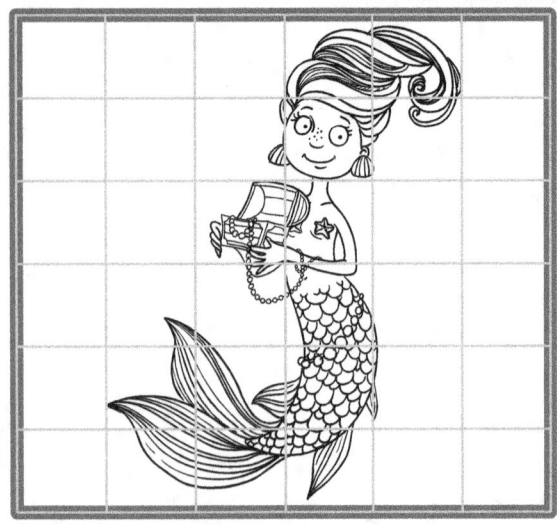

DRAW
THE
IMAGE

This is a Bleed Through Page If You Are Using a Coloring Marker or Pen!
Find Other Great Titles By searching for BoBo's Children Activity Books *on Your Favorite Book Retailer*
Amazon.Com | Barnes & Noble (BN.Com) | Books A Million (BAM.Com)

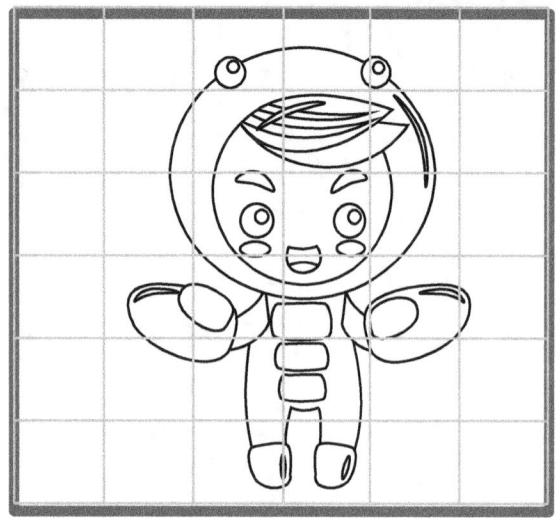

DRAW
THE
IMAGE

This is a Bleed Through Page If You Are Using a Coloring Marker or Pen!
Find Other Great Titles By searching for BoBo's Children Activity Books *on Your Favorite Book Retailer*
Amazon.Com | Barnes & Noble (BN.Com) | Books A Million (BAM.Com)

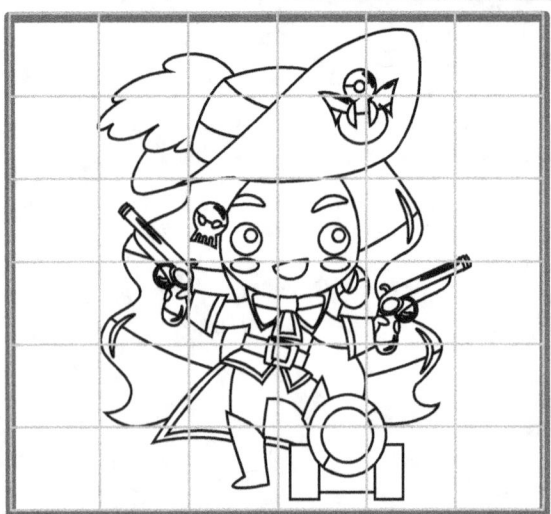

DRAW
THE
IMAGE

This is a Bleed Through Page If You Are Using a Coloring Marker or Pen!
Find Other Great Titles By searching for BoBo's Children Activity Books on Your Favorite Book Retailer
Amazon.Com | Barnes & Noble (BN.Com) | Books A Million (BAM.Com)

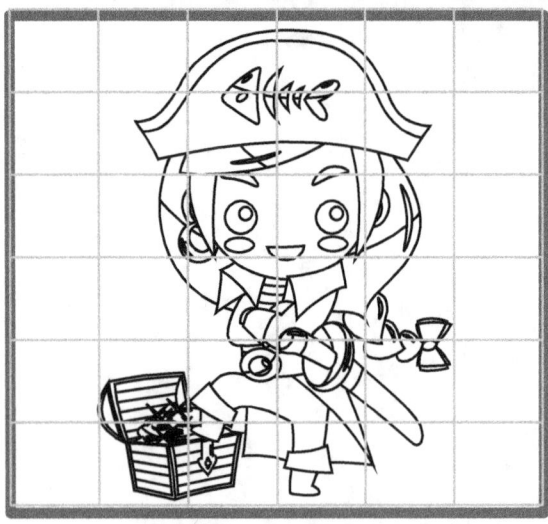

DRAW
THE
IMAGE

This is a Bleed Through Page If You Are Using a Coloring Marker or Pen!
Find Other Great Titles By searching for BoBo's Children Activity Books on Your Favorite Book Retailer
Amazon.Com | Barnes & Noble (BN.Com) | Books A Million (BAM.Com)

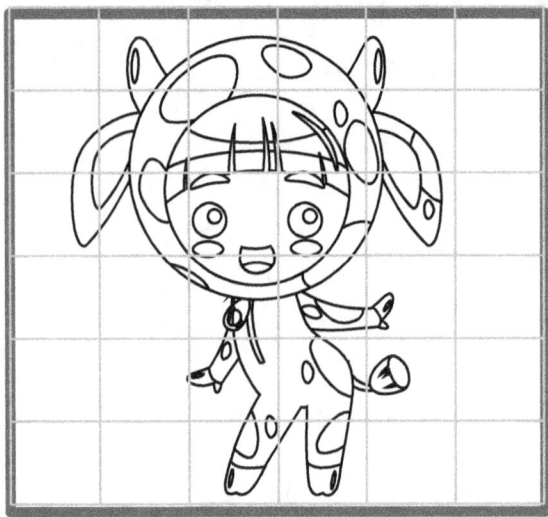

DRAW
THE
IMAGE

This is a Bleed Through Page If You Are Using a Coloring Marker or Pen!
Find Other Great Titles By searching for BoBo's Children Activity Books on Your Favorite Book Retailer
Amazon.Com | Barnes & Noble (BN.Com) | Books A Million (BAM.Com)

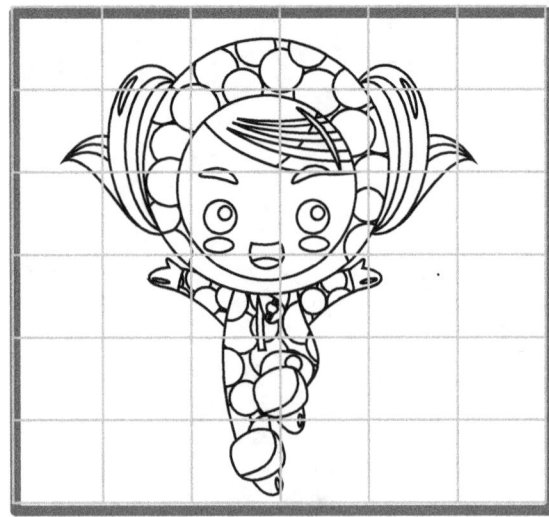

DRAW
THE
IMAGE

This is a Bleed Through Page If You Are Using a Coloring Marker or Pen!
Find Other Great Titles By searching for BoBo's Children Activity Books *on Your Favorite Book Retailer*
Amazon.Com | Barnes & Noble (BN.Com) | Books A Million (BAM.Com)

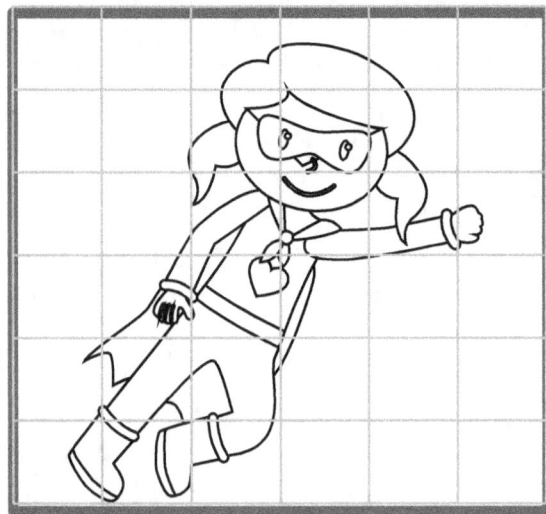

DRAW
THE
IMAGE

This is a Bleed Through Page If You Are Using a Coloring Marker or Pen!
Find Other Great Titles By searching for BoBo's Children Activity Books on Your Favorite Book Retailer
Amazon.Com | Barnes & Noble (BN.Com) | Books A Million (BAM.Com)

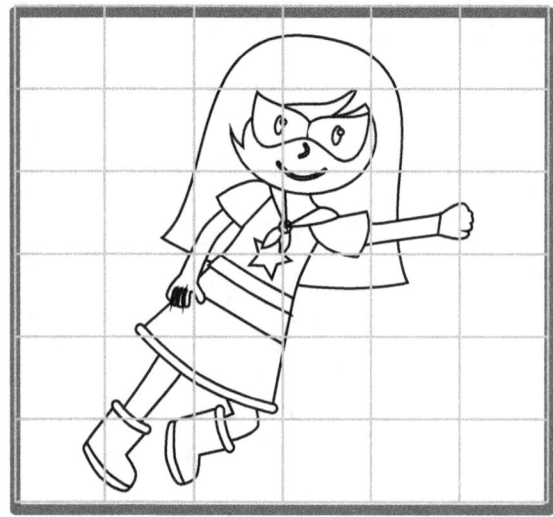

DRAW
THE
IMAGE

This is a Bleed Through Page If You Are Using a Coloring Marker or Pen!
Find Other Great Titles By searching for BoBo's Children Activity Books on Your Favorite Book Retailer
Amazon.Com | Barnes & Noble (BN.Com) | Books A Million (BAM.Com)

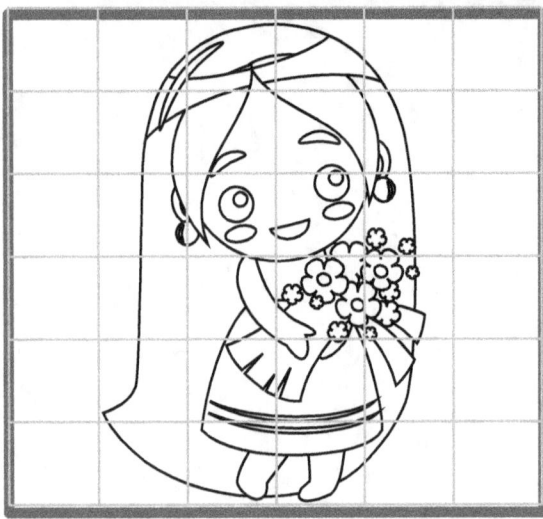

DRAW
THE
IMAGE

This is a Bleed Through Page If You Are Using a Coloring Marker or Pen!
Find Other Great Titles By searching for BoBo's Children Activity Books on Your Favorite Book Retailer
Amazon.Com | Barnes & Noble (BN.Com) | Books A Million (BAM.Com)

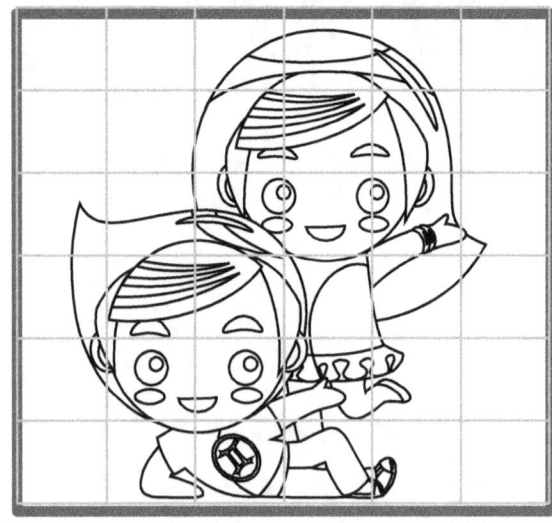

DRAW
THE
IMAGE

This is a Bleed Through Page If You Are Using a Coloring Marker or Pen!
Find Other Great Titles By searching for BoBo's Children Activity Books on Your Favorite Book Retailer
Amazon.Com | Barnes & Noble (BN.Com) | Books A Million (BAM.Com)

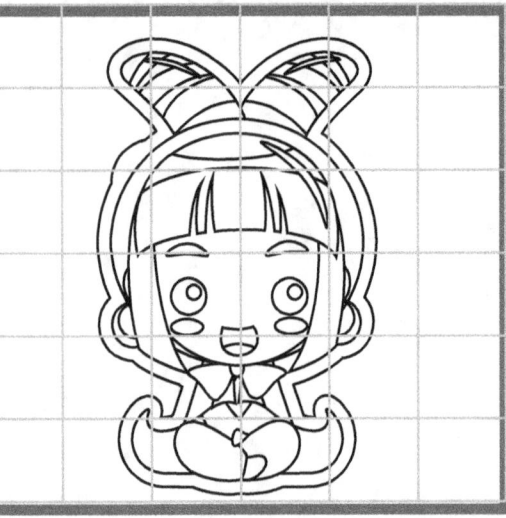

DRAW
THE
IMAGE

This is a Bleed Through Page If You Are Using a Coloring Marker or Pen!
Find Other Great Titles By searching for BoBo's Children Activity Books on Your Favorite Book Retailer
Amazon.Com | Barnes & Noble (BN.Com) | Books A Million (BAM.Com)

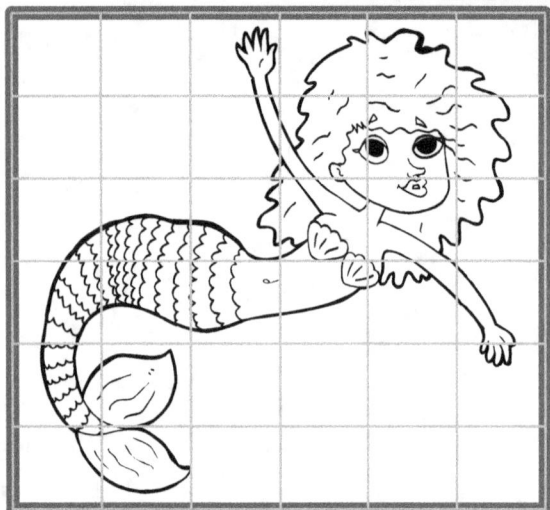

DRAW
THE
IMAGE

This is a Bleed Through Page If You Are Using a Coloring Marker or Pen!
Find Other Great Titles By searching for BoBo's Children Activity Books on Your Favorite Book Retailer
Amazon.Com | Barnes & Noble (BN.Com) | Books A Million (BAM.Com)

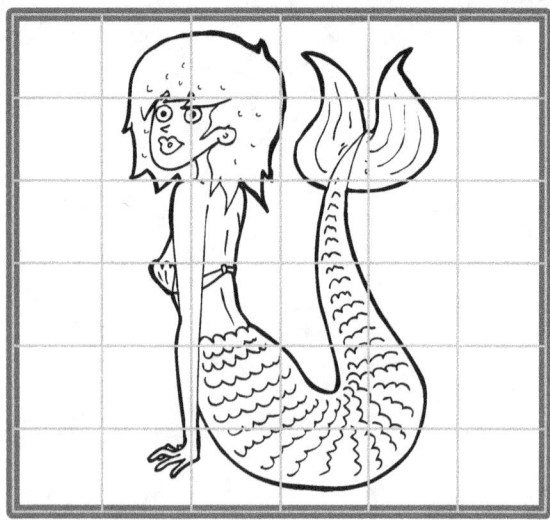

DRAW
THE
IMAGE

This is a Bleed Through Page If You Are Using a Coloring Marker or Pen!
Find Other Great Titles By searching for BoBo's Children Activity Books on Your Favorite Book Retailer
Amazon.Com | Barnes & Noble (BN.Com) | Books A Million (BAM.Com)

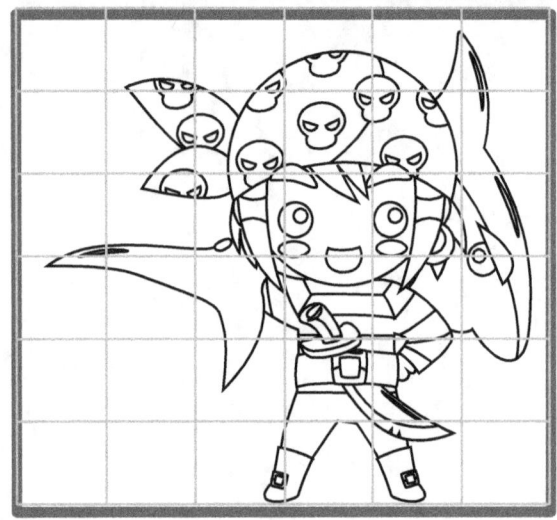

DRAW
THE
IMAGE

This is a Bleed Through Page If You Are Using a Coloring Marker or Pen!
Find Other Great Titles By searching for BoBo's Children Activity Books on Your Favorite Book Retailer
Amazon.Com | Barnes & Noble (BN.Com) | Books A Million (BAM.Com)

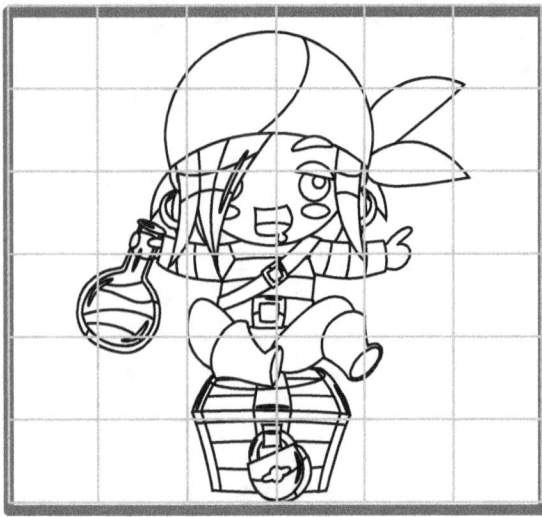

DRAW
THE
IMAGE

This is a Bleed Through Page If You Are Using a Coloring Marker or Pen!
Find Other Great Titles By searching for BoBo's Children Activity Books on Your Favorite Book Retailer
Amazon.Com | Barnes & Noble (BN.Com) | Books A Million (BAM.Com)

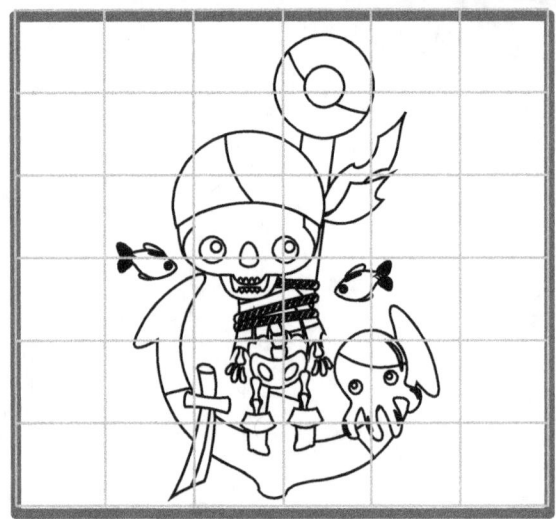

DRAW
THE
IMAGE

This is a Bleed Through Page If You Are Using a Coloring Marker or Pen!
Find Other Great Titles By searching for BoBo's Children Activity Books on Your Favorite Book Retailer
Amazon.Com | Barnes & Noble (BN.Com) | Books A Million (BAM.Com)

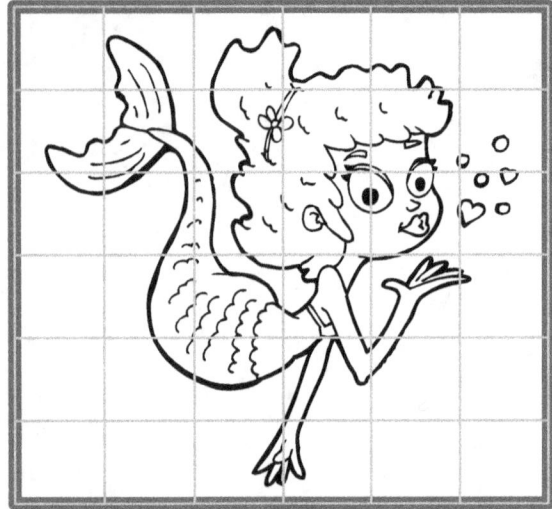

DRAW
THE
IMAGE

This is a Bleed Through Page If You Are Using a Coloring Marker or Pen!
Find Other Great Titles By searching for BoBo's Children Activity Books on Your Favorite Book Retailer
Amazon.Com | Barnes & Noble (BN.Com) | Books A Million (BAM.Com)

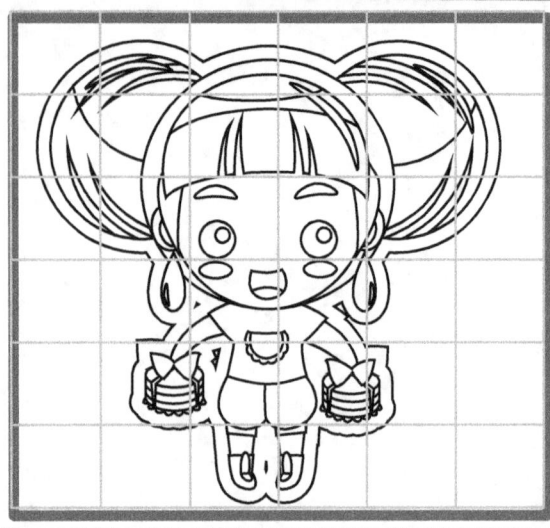

DRAW
THE
IMAGE

This is a Bleed Through Page If You Are Using a Coloring Marker or Pen!
Find Other Great Titles By searching for BoBo's Children Activity Books *on Your Favorite Book Retailer*
Amazon.Com | Barnes & Noble (BN.Com) | Books A Million (BAM.Com)

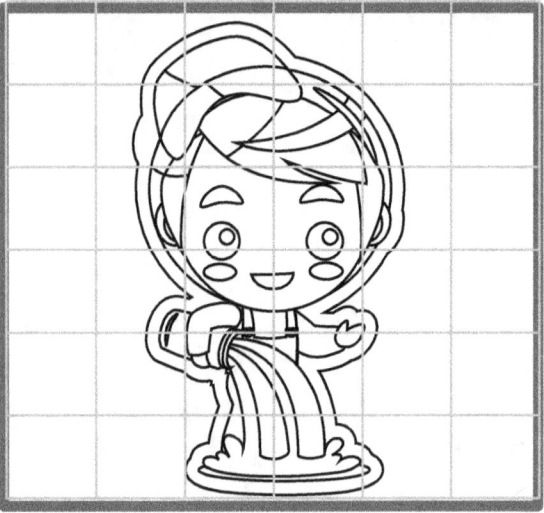

DRAW
THE
IMAGE

This is a Bleed Through Page If You Are Using a Coloring Marker or Pen!
Find Other Great Titles By searching for BoBo's Children Activity Books on Your Favorite Book Retailer
Amazon.Com | Barnes & Noble (BN.Com) | Books A Million (BAM.Com)

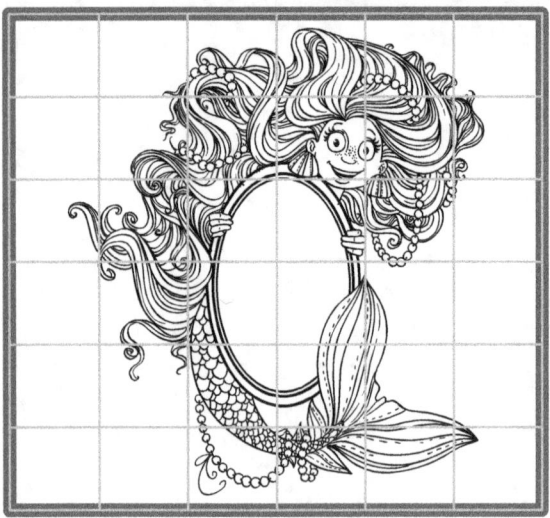

DRAW
THE
IMAGE

This is a Bleed Through Page If You Are Using a Coloring Marker or Pen!
Find Other Great Titles By searching for BoBo's Children Activity Books on Your Favorite Book Retailer
Amazon.Com | Barnes & Noble (BN.Com) | Books A Million (BAM.Com)

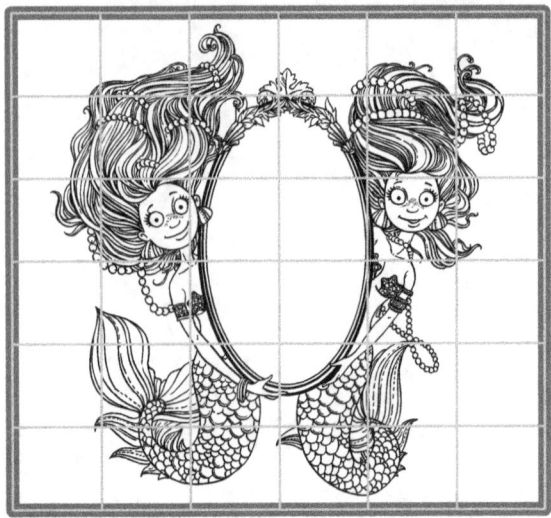

DRAW
THE
IMAGE

This is a Bleed Through Page If You Are Using a Coloring Marker or Pen!
Find Other Great Titles By searching for BoBo's Children Activity Books on Your Favorite Book Retailer
Amazon.Com | Barnes & Noble (BN.Com) | Books A Million (BAM.Com)

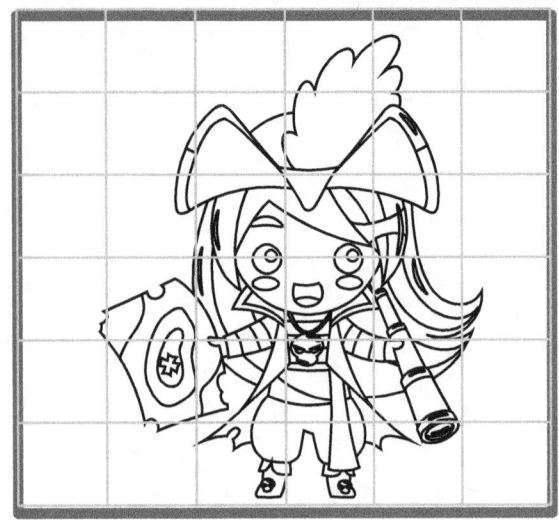

DRAW THE IMAGE

This is a Bleed Through Page If You Are Using a Coloring Marker or Pen!
Find Other Great Titles By searching for BoBo's Children Activity Books *on Your Favorite Book Retailer*
Amazon.Com | Barnes & Noble (BN.Com) | Books A Million (BAM.Com)

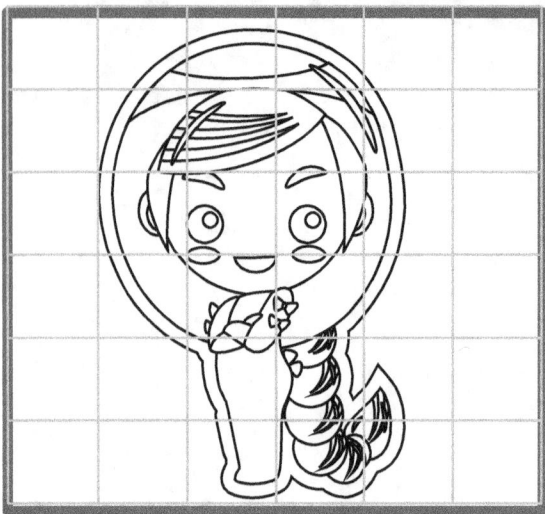

DRAW
THE
IMAGE

This is a Bleed Through Page If You Are Using a Coloring Marker or Pen!
Find Other Great Titles By searching for BoBo's Children Activity Books on Your Favorite Book Retailer
Amazon.Com | Barnes & Noble (BN.Com) | Books A Million (BAM.Com)

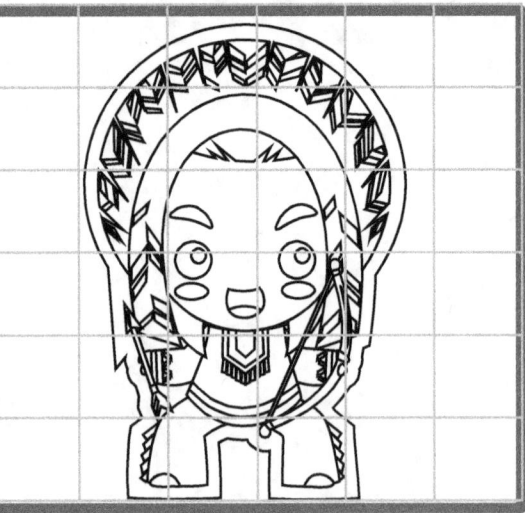

DRAW
THE
IMAGE

This is a Bleed Through Page If You Are Using a Coloring Marker or Pen!
Find Other Great Titles By searching for BoBo's Children Activity Books on Your Favorite Book Retailer
Amazon.Com | Barnes & Noble (BN.Com) | Books A Million (BAM.Com)

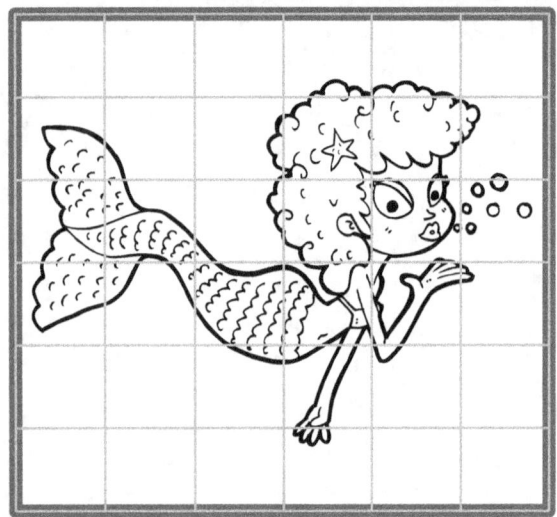

DRAW
THE
IMAGE

This is a Bleed Through Page If You Are Using a Coloring Marker or Pen!
Find Other Great Titles By searching for BoBo's Children Activity Books on Your Favorite Book Retailer
Amazon.Com | Barnes & Noble (BN.Com) | Books A Million (BAM.Com)

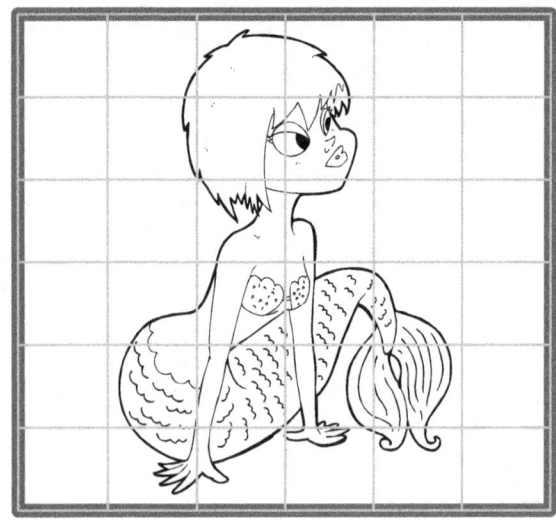

DRAW
THE
IMAGE

This is a Bleed Through Page If You Are Using a Coloring Marker or Pen!
Find Other Great Titles By searching for BoBo's Children Activity Books on Your Favorite Book Retailer
Amazon.Com | Barnes & Noble (BN.Com) | Books A Million (BAM.Com)

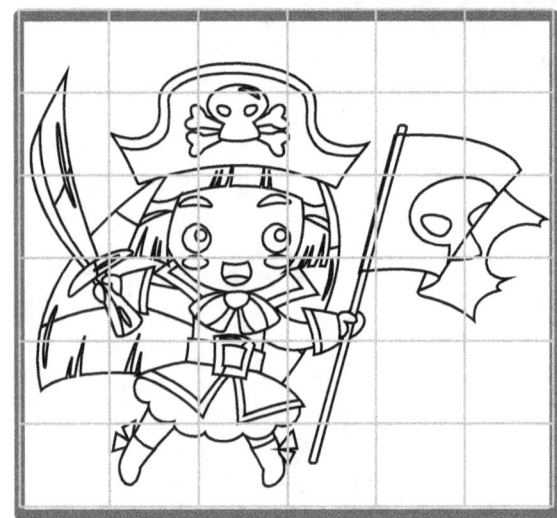

DRAW
THE
IMAGE

This is a Bleed Through Page If You Are Using a Coloring Marker or Pen!
Find Other Great Titles By searching for BoBo's Children Activity Books on Your Favorite Book Retailer
Amazon.Com | Barnes & Noble (BN.Com) | Books A Million (BAM.Com)

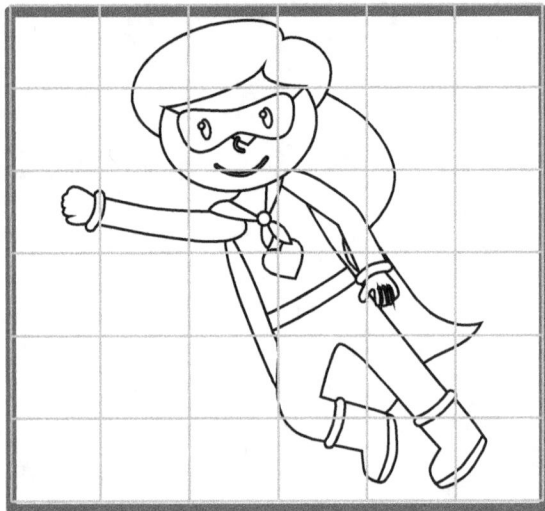

DRAW
THE
IMAGE

This is a Bleed Through Page If You Are Using a Coloring Marker or Pen!
Find Other Great Titles By searching for BoBo's Children Activity Books on Your Favorite Book Retailer
Amazon.Com | Barnes & Noble (BN.Com) | Books A Million (BAM.Com)

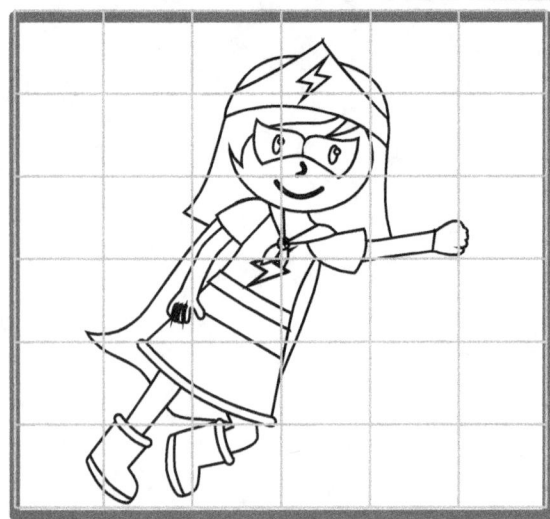

DRAW
THE
IMAGE

This is a Bleed Through Page If You Are Using a Coloring Marker or Pen!
Find Other Great Titles By searching for BoBo's Children Activity Books on Your Favorite Book Retailer
Amazon.Com | Barnes & Noble (BN.Com) | Books A Million (BAM.Com)

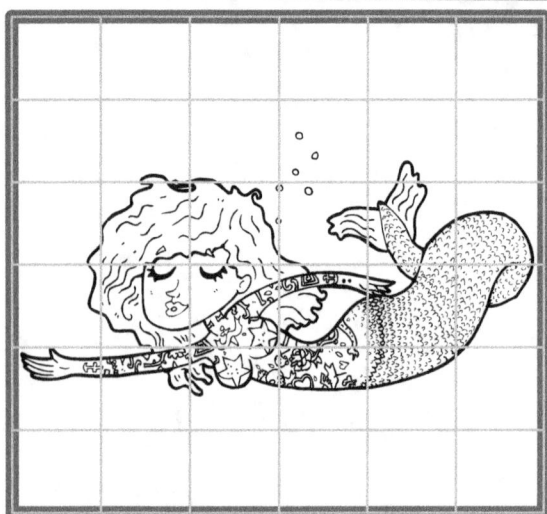

DRAW
THE
IMAGE

This is a Bleed Through Page If You Are Using a Coloring Marker or Pen!
Find Other Great Titles By searching for BoBo's Children Activity Books on Your Favorite Book Retailer
Amazon.Com | Barnes & Noble (BN.Com) | Books A Million (BAM.Com)

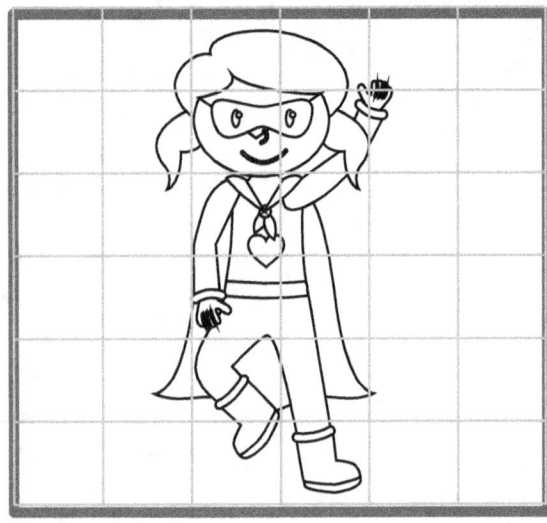

DRAW
THE
IMAGE

This is a Bleed Through Page If You Are Using a Coloring Marker or Pen!
Find Other Great Titles By searching for BoBo's Children Activity Books on Your Favorite Book Retailer
Amazon.Com | Barnes & Noble (BN.Com) | Books A Million (BAM.Com)

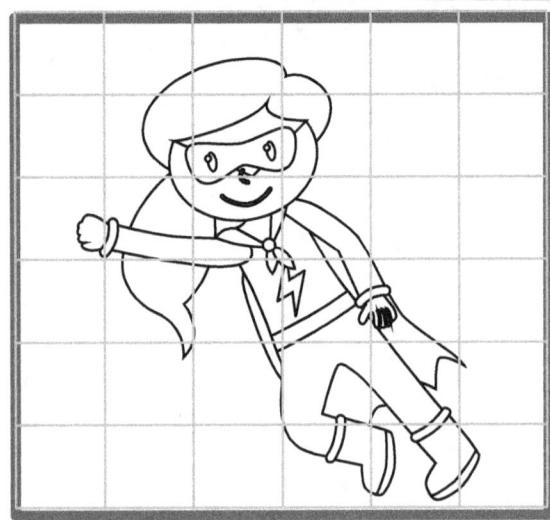

DRAW
THE
IMAGE

This is a Bleed Through Page If You Are Using a Coloring Marker or Pen!
Find Other Great Titles By searching for BoBo's Children Activity Books on Your Favorite Book Retailer
Amazon.Com | Barnes & Noble (BN.Com) | Books A Million (BAM.Com)

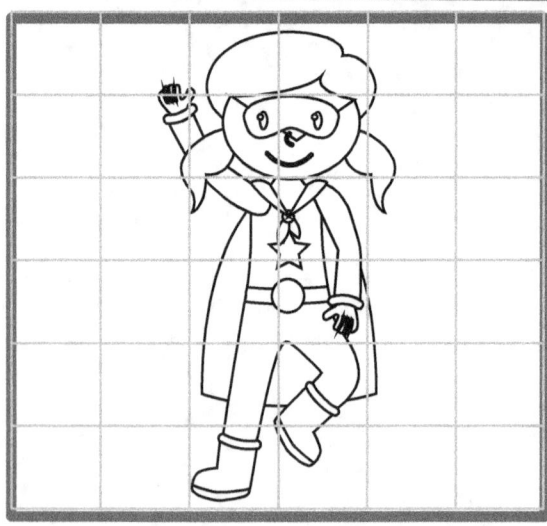

DRAW
THE
IMAGE

This is a Bleed Through Page If You Are Using a Coloring Marker or Pen!
Find Other Great Titles By searching for BoBo's Children Activity Books on Your Favorite Book Retailer
Amazon.Com | Barnes & Noble (BN.Com) | Books A Million (BAM.Com)

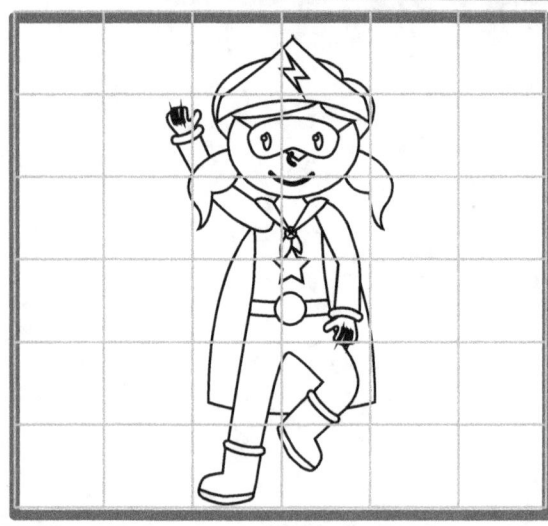

DRAW
THE
IMAGE

This is a Bleed Through Page If You Are Using a Coloring Marker or Pen!
Find Other Great Titles By searching for BoBo's Children Activity Books on Your Favorite Book Retailer
Amazon.Com | Barnes & Noble (BN.Com) | Books A Million (BAM.Com)

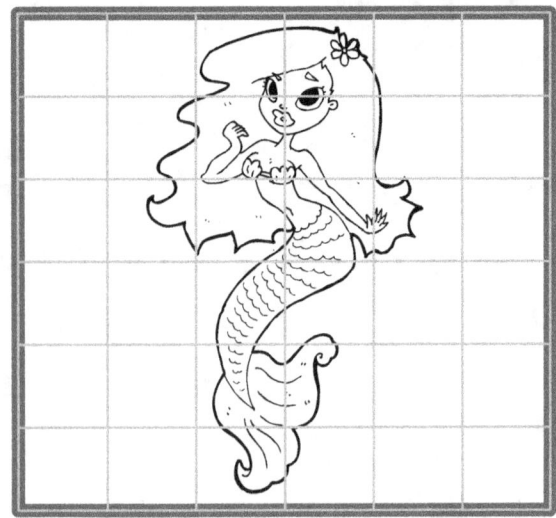

DRAW
THE
IMAGE

This is a Bleed Through Page If You Are Using a Coloring Marker or Pen!
Find Other Great Titles By searching for BoBo's Children Activity Books *on Your Favorite Book Retailer*
Amazon.Com | Barnes & Noble (BN.Com) | Books A Million (BAM.Com)

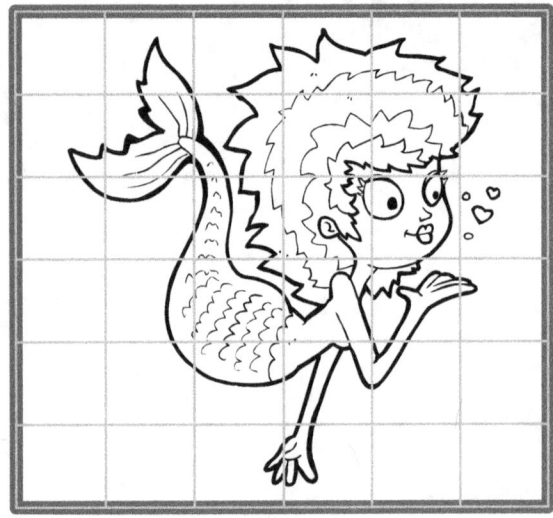

DRAW
THE
IMAGE

This is a Bleed Through Page If You Are Using a Coloring Marker or Pen!
Find Other Great Titles By searching for BoBo's Children Activity Books *on Your Favorite Book Retailer*
Amazon.Com | Barnes & Noble (BN.Com) | Books A Million (BAM.Com)

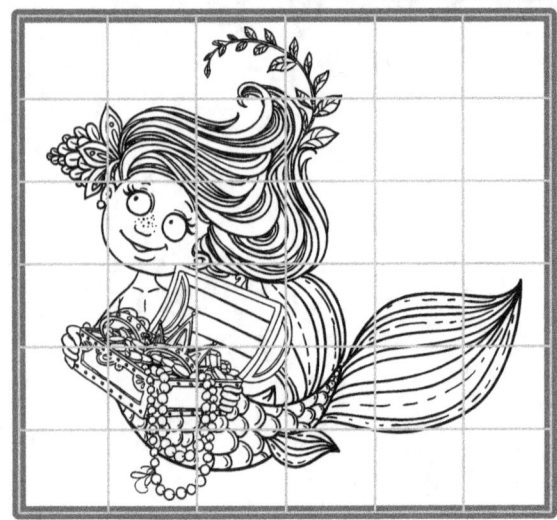

DRAW
THE
IMAGE

This is a Bleed Through Page If You Are Using a Coloring Marker or Pen!
Find Other Great Titles By searching for BoBo's Children Activity Books on Your Favorite Book Retailer
Amazon.Com | Barnes & Noble (BN.Com) | Books A Million (BAM.Com)

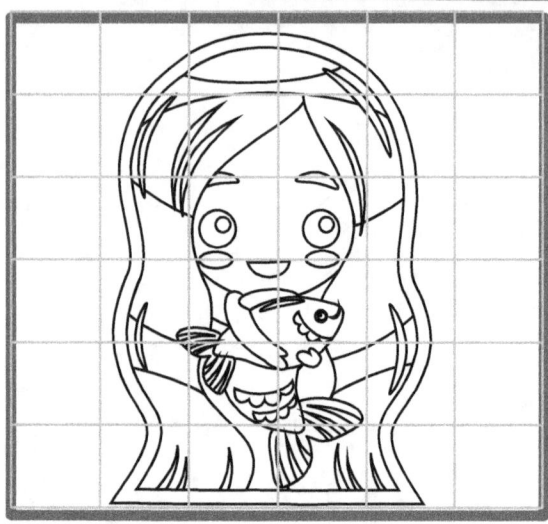

DRAW
THE
IMAGE

Turn this page and learn to draw a UNICORN

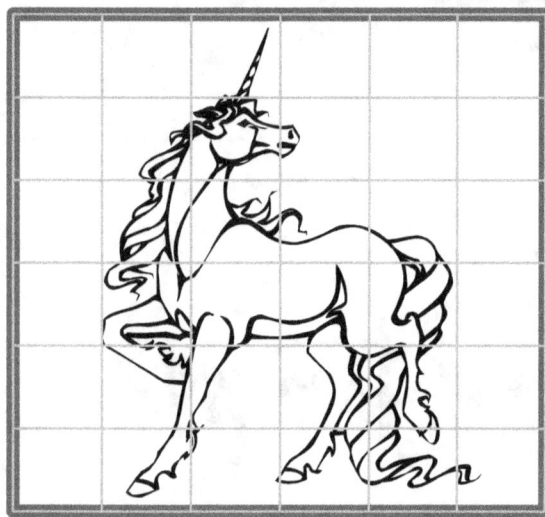

DRAW
THE
IMAGE

This is a Bleed Through Page If You Are Using a Coloring Marker or Pen!
Find Other Great Titles By searching for BoBo's Children Activity Books on Your Favorite Book Retailer
Amazon.Com | Barnes & Noble (BN.Com) | Books A Million (BAM.Com)

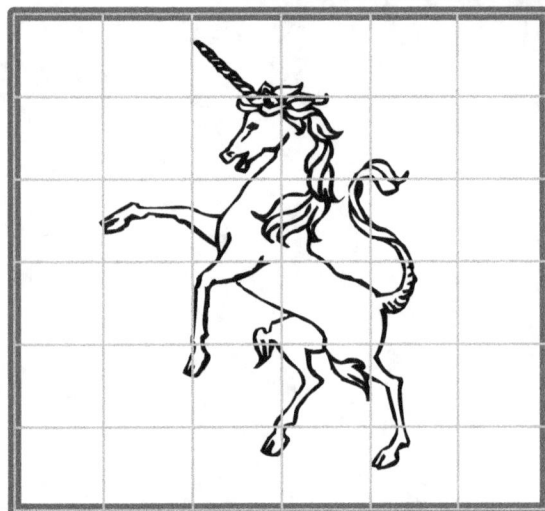

DRAW
THE
IMAGE

This is a Bleed Through Page If You Are Using a Coloring Marker or Pen!
Find Other Great Titles By searching for <u>BoBo's Children Activity Books</u> on Your Favorite Book Retailer
Amazon.Com | Barnes & Noble (BN.Com) | Books A Million (BAM.Com)

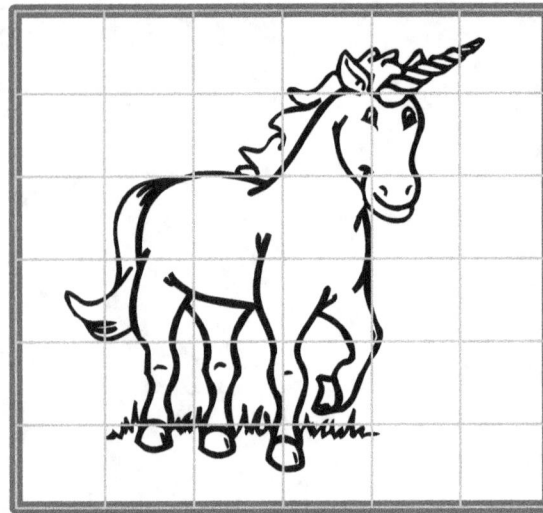

DRAW
THE
IMAGE

This is a Bleed Through Page If You Are Using a Coloring Marker or Pen!
Find Other Great Titles By searching for BoBo's Children Activity Books on Your Favorite Book Retailer
Amazon.Com | Barnes & Noble (BN.Com) | Books A Million (BAM.Com)

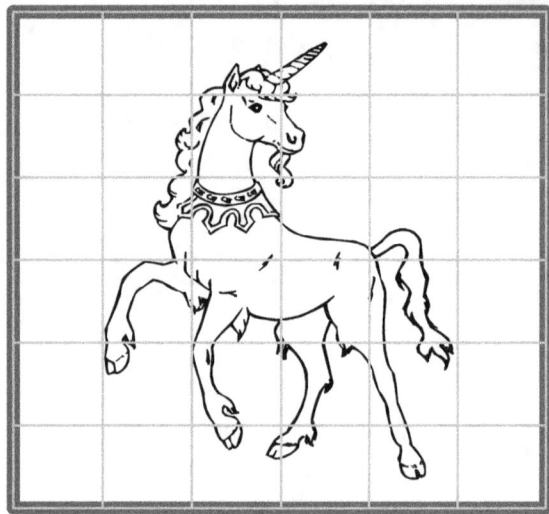

DRAW
THE
IMAGE

This is a Bleed Through Page If You Are Using a Coloring Marker or Pen!
Find Other Great Titles By searching for BoBo's Children Activity Books on Your Favorite Book Retailer
Amazon.Com | Barnes & Noble (BN.Com) | Books A Million (BAM.Com)

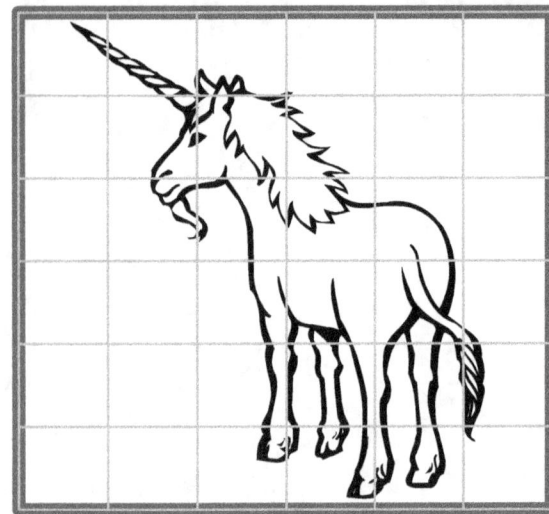

DRAW
THE
IMAGE

This is a Bleed Through Page If You Are Using a Coloring Marker or Pen!
Find Other Great Titles By searching for BoBo's Children Activity Books on Your Favorite Book Retailer
Amazon.Com | Barnes & Noble (BN.Com) | Books A Million (BAM.Com)

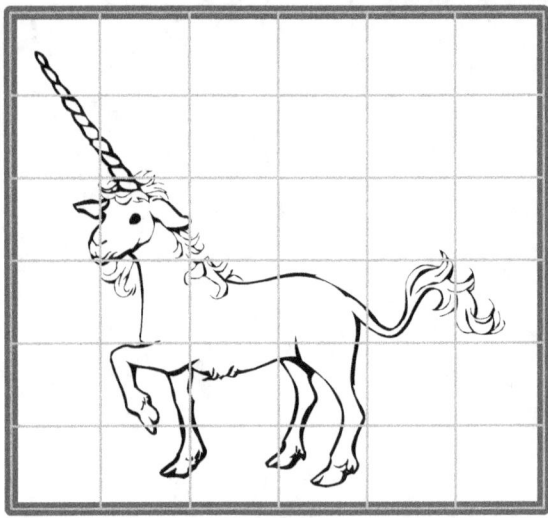

DRAW
THE
IMAGE

This is a Bleed Through Page If You Are Using a Coloring Marker or Pen!
Find Other Great Titles By searching for BoBo's Children Activity Books on Your Favorite Book Retailer
Amazon.Com | Barnes & Noble (BN.Com) | Books A Million (BAM.Com)

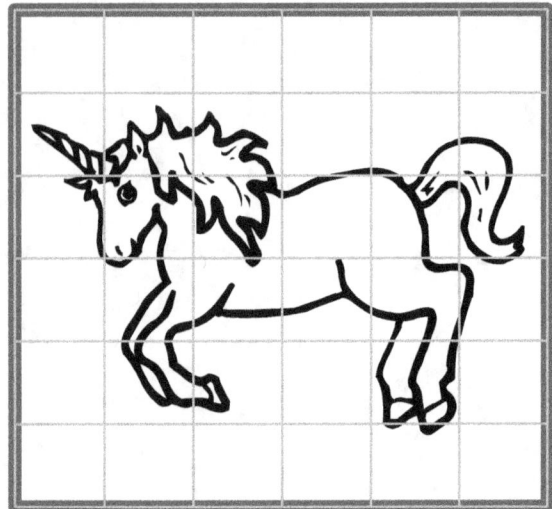

DRAW
THE
IMAGE

This is a Bleed Through Page If You Are Using a Coloring Marker or Pen!
Find Other Great Titles By searching for BoBo's Children Activity Books on Your Favorite Book Retailer
Amazon.Com | Barnes & Noble (BN.Com) | Books A Million (BAM.Com)

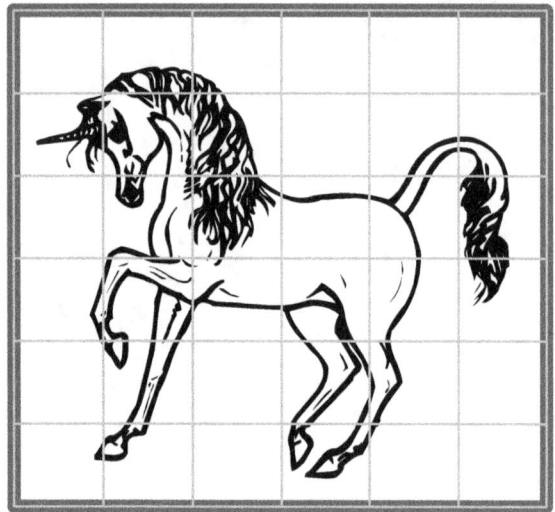

DRAW
THE
IMAGE

This is a Bleed Through Page If You Are Using a Coloring Marker or Pen!
Find Other Great Titles By searching for BoBo's Children Activity Books on Your Favorite Book Retailer
Amazon.Com | Barnes & Noble (BN.Com) | Books A Million (BAM.Com)

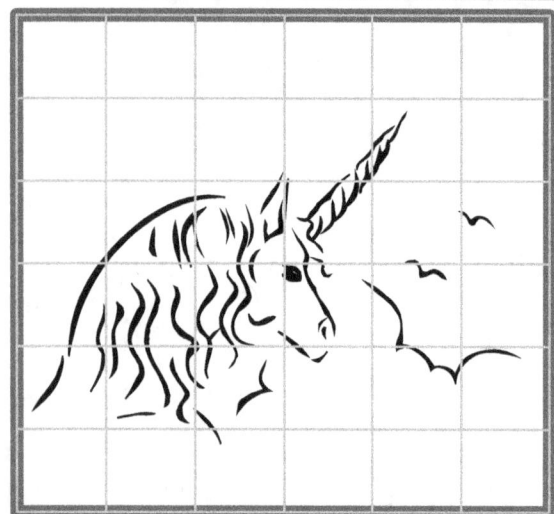

DRAW
THE
IMAGE

This is a Bleed Through Page If You Are Using a Coloring Marker or Pen!
Find Other Other Great Titles By searching for BoBo's Children Activity Books on Your Favorite Book Retailer
Amazon.Com | Barnes & Noble (BN.Com) | Books A Million (BAM.Com)

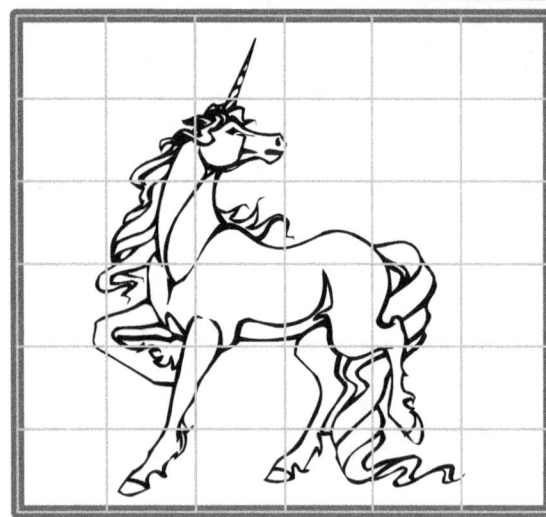

DRAW
THE
IMAGE

This is a Bleed Through Page If You Are Using a Coloring Marker or Pen!
Find Other Great Titles By searching for BoBo's Children Activity Books on Your Favorite Book Retailer
Amazon.Com | Barnes & Noble (BN.Com) | Books A Million (BAM.Com)

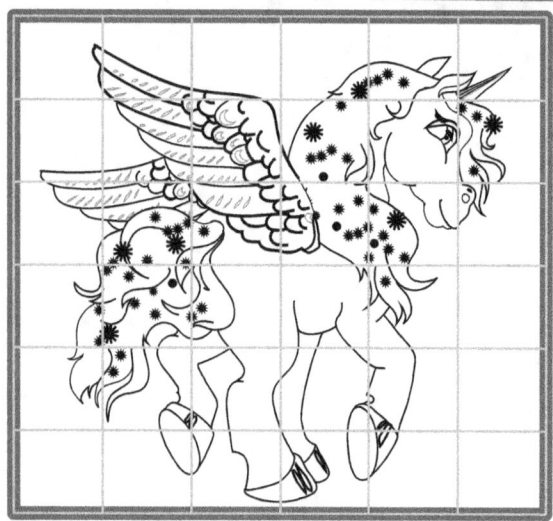

DRAW
THE
IMAGE

This is a Bleed Through Page If You Are Using a Coloring Marker or Pen!
Find Other Great Titles By searching for BoBo's Children Activity Books on Your Favorite Book Retailer
Amazon.Com | Barnes & Noble (BN.Com) | Books A Million (BAM.Com)

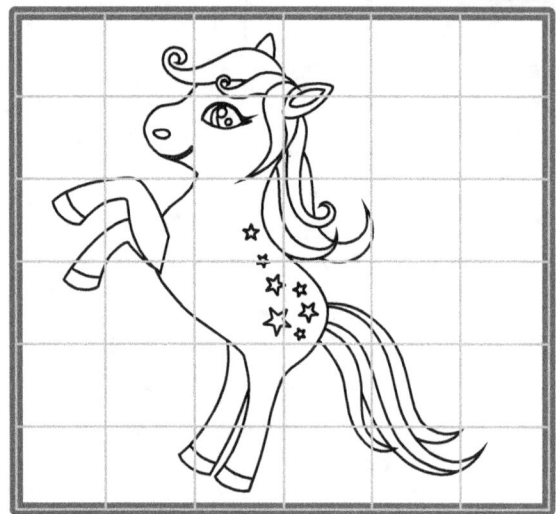

DRAW
THE
IMAGE

This is a Bleed Through Page If You Are Using a Coloring Marker or Pen!
Find Other Great Titles By searching for BoBo's Children Activity Books on Your Favorite Book Retailer
Amazon.Com | Barnes & Noble (BN.Com) | Books A Million (BAM.Com)

This is a Bleed Through Page If You Are Using a Coloring Marker or Pen!
Find Other Great Titles By searching for BoBo's Children Activity Books on Your Favorite Book Retailer
Amazon.Com | Barnes & Noble (BN.Com) | Books A Million (BAM.Com)

www.ingramcontent.com/pod-product-compliance
Lightning Source LLC
Chambersburg PA
CBHW081437220526
45466CB00008B/2424